W9-CFT-888

What is Post-Modernism?

BY CHARLES JENCKS

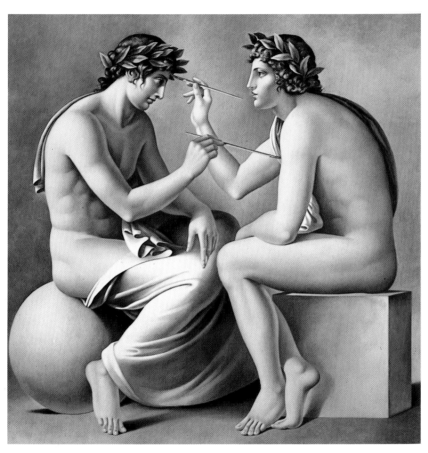

Carlo Maria Mariani, *La Mano Ubbidisce all'Inteletto*, 1983, oil on canvas, 78½ x 69in. For Modernists the subject of art was often the process of art; for Post-Modernists it is often the history of art. Mariani adapts eighteenth-century conventions, including even the 'erotic frigidaire', to portray his allegory of autogenous creation: art painting itself. *The Hand Submits to the Intellect* recalls the Greek myth of the origins of painting and suggests that art today is still self-generated and as hermetically sealed as his ideal, claustrophobic space. (Courtesy of Sperone Westwater Gallery, New York)

FOREWORD

The growth of Post-Modernism has followed a sinuous, even tortuous, path. Twisting to the left and then to the right, branching down the middle, it resembles the natural form of a spreading root, or a meandering river that divides, changes course, doubles back on itself and takes off in a new direction. Its meaning is still in dispute not only because of this change but also because it signifies two quite different traditions to writers, philosophers and artists. Seen as progressive in some quarters, it is damned as reactionary and nostalgic in others; supported for its social and technological realism, it is also accused of escapism. Even, at times, when it is being condemned for its schizophrenia this 'failing' is turned, by its defenders, into a virtue. Like its parent, Modernism, it inevitably has the faults of any movement in contemporary society, the most obvious being an overproduction of artefacts and an inflation of theory. Indeed one critic of Post-Modern writing, Charles Newman, finds its defining quality to be the runaway growth typified by a multiplying economy.[1] But a critical reading of the evidence will show that the same problems of fast-track production and consumption beset other modern movements, and one can legitimately

© 1986 Copyright Art & Design. *All rights reserved.*

This paper was first given at a conference on Post-Modernism at Northwestern University, Evanston, Illinois in October 1985, and again later that month in Hannover, Germany, at a second conference on the same subject organised by Dr Peter Koslowski for *Civitas*.

NOTES

1 See Charles Newman, *The Post-Modern Aura: The Act of Fiction in an Age of Inflation*, with a preface by Gerald Graff, Northwestern University Press, Evanston, Illinois 1985.

2 See Irving Howe, 'Mass Society and Postmodern Fiction' (1963) in *The Decline of the New*, Harcourt Brace and World, New York 1970. *The Decline of the New*, as the title suggests, also treats the subject. See also Gerald

speak of a mass-culture Modernism, a kitsch Futurism, a nostalgic Late-Modernism, and so forth. Overproduction and its attendant consequence of devaluation are, unfortunately, democratically shared by all Modernisms.

The concept was apparently first used by the Spanish writer Federico De Onis in his *Antología de la poesía española e hispanoamericana*, 1934, to describe a reaction from within Modernism, and then by Arnold Toynbee in his *A Study of History* written in 1938, but published after the war in 1947. For Toynbee the term was an encompassing category describing the new historical cycle which started in 1875 with the end of western dominance, the decline of individualism, capitalism and Christianity, and the rise to power of non-western cultures. In addition it referred to a pluralism and world culture, meanings which are still essential to its definition today, and positively so. But Toynbee was, on the whole, sceptical of the 'world village' – as McLuhan was later to term it – and it is interesting that this scepticism was shared by those writers who first used the term polemically, the literary critics Irving Howe and Harold Levine, for this essentially negative description has stayed with the movement becoming in the event both a scourge and a challenge, an insult and a slogan to be carried into battle.[2] Their usage, in 1963 and 1966, was – as E.H. Gombrich has shown of the first use of the terms Gothic, Mannerism, Baroque, Rococo and Romanesque – malevolent enough to sting, catch on and then become positive.[3] Labels, like the movements they describe, often have this paradoxical power: to issue fruitfully from the mouths of detractors. No wonder their growth can resemble a twisting, organic shape, not only a tree or a river but, in the case of Post-Modernism, a snake.

Virtually the first positive use of the prefix 'post' was by the writer Leslie Fiedler in 1965 when he repeated it like an incantation and tied it to current radical trends which made up the counter-culture: 'post-humanist, post-male, post-white, post-heroic . . . post-Jewish'.[4] These anarchic and creative departures from orthodoxy, these attacks on Modernist elitism, academicism and puritanical repression, do indeed represent the first stirrings of Post-Modern culture as Andreas Huyssen later pointed out in 1984, although Fiedler and others in the 1960s were never to put this argument as such and conceptualise the

Graff, 'The Myth of the Postmodern Breakthrough' reprinted in *Literature Against Itself*, The University of Chicago Press, Chicago and London 1979. Graff's critique of the Post-Modern seems to be more aptly directed at Late-Modern literature, as I mentioned to him when we met at a conference in Evanston, 1985, but he is using the term as defined by Howe, Levin, Charles Olsen, Hassan and others. For Harold Levin see 'What was Modernism?', *Refractions: Essays in Comparative Literature*, Oxford University Press, New York 1966.

3 For this idea and a discussion of several terms see E.H. Gombrich, 'The Origins of Stylistic Terminology', *Norm and Form*, Phaidon, London 1966, pp. 83-6, and 'Mannerism: The Historiographic Background', also printed in *Norm and Form*, pp. 99-106.

4 See Leslie Fiedler, 'The New Mutants' (1965) published in *The Collected Essays of Leslie Fiedler Vol. II*, Stein and Day, New York 1970, and *A Fiedler Reader*, Stein and Day, New York 1977, pp. 189-210.

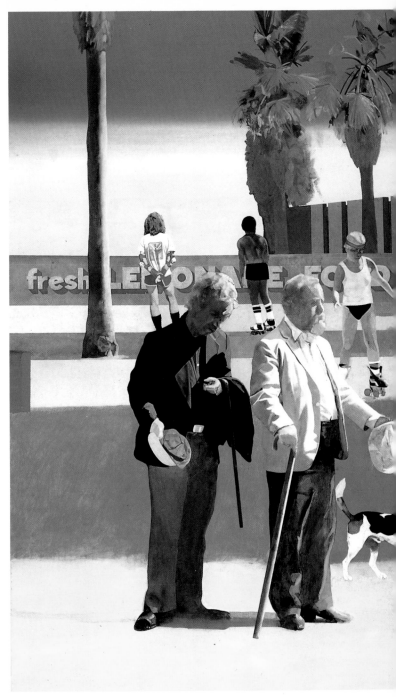

[1] Peter Blake, 'The Meeting' or 'Have a Nice Day, Mr Hockney', 1981-3, oil on canvas, 39 x 49in. An ironic meeting of 1960s 'Pop' painters at the Post-Modern academy in the 1980s. This new version of Courbet's The Meeting or Bonjour Monsieur Courbet is both a contemporary comment on Classicism and a classical composition in itself. The meeting is between three representational artists – Howard Hodgkin, Peter Blake and David Hockney – the last with a

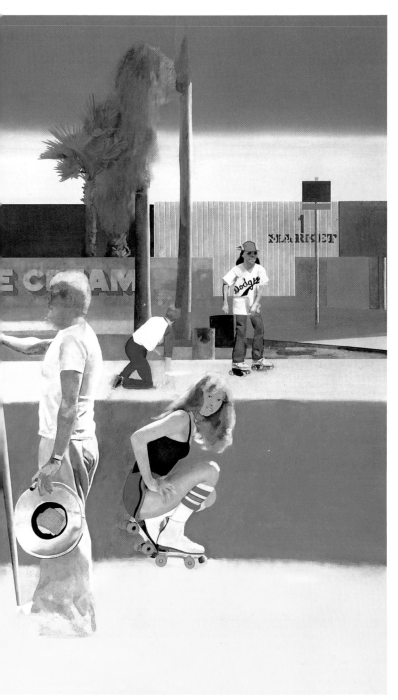

brush rather than a staff in his hand. The squatting girl's pose is taken partly from a skating magazine and partly from classical sculpture. The heroic meeting in 'Venice', California, commemorates a historical act, if not a grand public one, as the nineteenth-century Classicist would no doubt have preferred. Monumentality and banality, a timeless present and the transient afternoon are set in serene contrast. (Courtesy of the Tate Gallery, London)

tradition.[5] This had to wait until the 1970s and the writings of Ihab Hassan, by which time the radical movements which Fiedler celebrated were, ironically, out of fashion, reactionary or dead.

Ihab Hassan became by the mid 1970s the self-proclaimed spokesman for the Postmodern (the term is conventionally elided in literary criticism) and he tied this label to the ideas of experimentalism in the arts and ultra-technology in architecture – William Burroughs and Buckminster Fuller, 'Anarchy, Exhaustion/Silence . . . Decreation/ Deconstruction/Antithesis . . . Intertext . . .' – in short those trends which I, with others, would later characterise as Late-Modern. In literature and then in philosophy, because of the writings of Jean-François Lyotard (1979) and a tendency to elide Deconstruction with the Post-Modern, the term has often kept its associations with what Hassan calls 'discontinuity, indeterminancy, immanence'.[6] Mark C. Taylor's curiously titled *ERRING, A Postmodern A/Theology* is characteristic of this genre which springs from Derrida and Deconstruction.[7] There is also a tendency among philosophers to discuss all Post-Positivist thinkers together as Post-Modern whether or not they have anything more in common than a rejection of Modern Logical Positivism. Thus there are two quite different meanings to the term and a general confusion which is not confined to the public. This and the pretext of several recent conferences on the subject has led to this little tract: 'What is Post-Modernism?' It *is* a question, as well as the answer I will give, and one must see that its continual growth and movement mean that no definitive answer is possible – at least not until it stops moving.

[1] In its infancy in the 1960s Post-Modern culture was radical and critical, a minority position established, for instance, by Pop artists and theorists against the reduced view of Modern art, the aestheticism reigning in such institutes as the Museum of Modern Art. In architecture, Team Ten, Jane Jacobs, Robert Venturi and the Advocacy Planners attacked 'orthodox Modern architecture' for its elitism, urban destruction, bureaucracy and simplified language. By the 1970s, as these traditions grew in strength and changed and Post-Modernism was now coined as a term for a variety of trends, the movement became more conservative, rational and academic. Many protagonists of the 1960s, such as Andy Warhol, lost their critical function altogether as they were assimilated into the art market or commercial practice. In the 1980s the situation changed again. Post-Modernism was finally accepted by the professions, academies and society at large. It became as much part of the establishment as its

5 See Andreas Huyssen, 'Mapping the Postmodern', *New German Critique*, No. 33, Fall 1984, devoted to *Modernity and Postmodernity*, University of Wisconsin-Milwaukee, 1984.

6 See Ihab Hassan, 'The Question of Postmodernism', *Romanticism, Modernism, Postmodernism*, Harry R. Garvin (ed.), Bucknell University Press, Lewisberg, Toronto and London 1980, pp. 117-26.

7 See Mark C. Taylor, *ERRING, A Postmodern A/Theology*, The University of Chicago Press, Chicago and London 1984.

parent, Modernism, and rival brother, Late-Modernism, and in literary criticism it shifted closer in meaning to the architectural and art traditions.

John Barth (1980), and Umberto Eco (1983), among many other authors, now define it as a writing which may use traditional forms in ironic or displaced ways to treat perennial themes.[8] It acknowledges the validity of Modernism – the change in the world view brought on by Nietzsche, Einstein, Freud et. al. – but, as John Barth says, it hopes to go beyond the limited means and audience which characterise Modernist fiction: 'My ideal postmodernist author neither merely repudiates nor merely imitates either his twentieth-century modernist parents or his nineteenth-century premodernist grandparents. He has the first half of our century under his belt, but not on his back. Without lapsing into moral or artistic simplism, shoddy craftsmanship, Madison Avenue venality, or either false or real naiveté, he nevertheless aspires to a fiction more democratic in its appeal than such late-modernist marvels (by my definition and in my judgement) as Beckett's *Stories and Texts for Nothing* or Nabokov's *Pale Fire*. He may not hope to reach and move the devotees of James Michener and Irving Wallace – not to mention the lobotomized mass-media illiterates. But he *should* hope to reach and delight, at least part of the time, beyond the circle of what Mann used to call the Early Christians: professional devotees of high art.'[9] This search for a wider audience than the Early Christians also distinguishes Post-Modern architects and artists from their Late- [2] Modern counterparts and from the more hermetic concerns that Ihab Hassan defined in the 1970s. There are of course many other specific goals on the agenda which give Post-Modernism a direction.

But because its meaning and tradition change, one must not only define the concept but give its dates and specific context. As the reader will find, I term Post-Modernism that paradoxical dualism, or double coding, which its hybrid name entails: the continuation of Modernism [3] and its transcendence. Hassan's 'postmodern' is, according to this logic, mostly Late-Modern, the continuation of Modernism in its ultra or exaggerated form. Some writers and critics, such as Barth and Eco, would agree with this definition, while just as many, including Hassan and Lyotard, would disagree. In this agreement and disagreement, understanding and dispute, there is the same snake-like dialectic which the movement has always shown and one suspects that there will be several more surprising twists of the coil before it is finished. Of one thing we can be sure: the announcement of death is, until the other Modernisms disappear, premature.

8 See John Barth, 'The Literature of Replenishment, Postmodernist Fiction', *The Atlantic*, January 1980, pp. 65-71, and Umberto Eco, 'Postmodernism, Irony, the Enjoyable, *Postscript to The Name of the Rose*, Harcourt Brace Jovanovich, New York and London 1984, first published in Italian, 1983. Umberto Eco's *The Name of the Rose* became, of course, a best-selling version of the kind of Post-Modern fiction that Barth and Eco describe in their theoretical writing.

9 John Barth, *op. cit.*, p. 70.

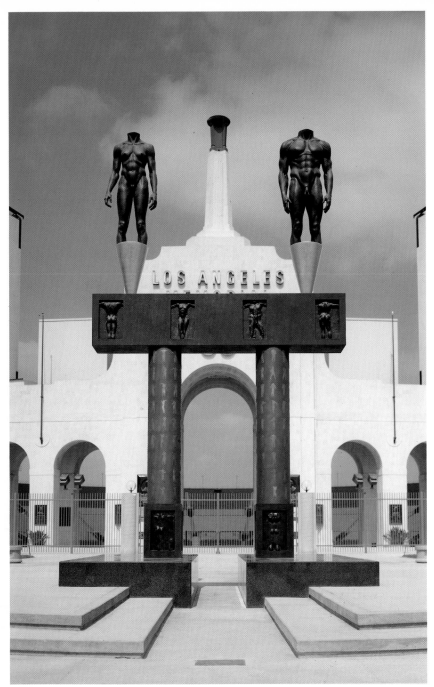

[2] Robert Graham, *Olympic Arch*, Los Angeles, 1984, bronze, metal and granite, c.20 x 12 x4ft. The search for a wider audience has led some sculptors towards urban commissions which comment on place and activity – a form of context-specific art. Here Olympic athletes, truncated to signify physical power, go through their exercises which are also those of the sculptor. The emphasis on 'perfect casting' and 'absolute realism' recalls classical norms while the disjunctions and combined materials make it unmistakably of the present. (Courtesy of the artist)

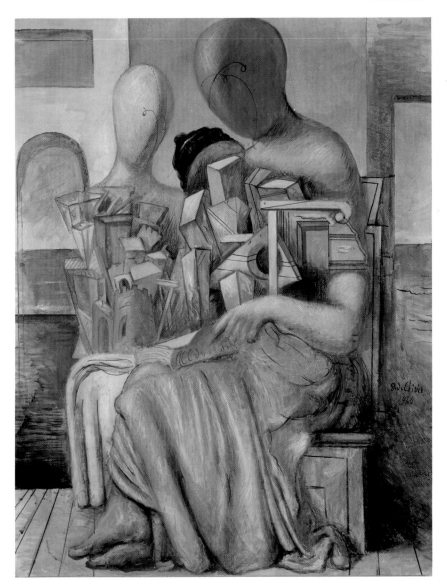

[3] Giorgio de Chirico, *La Lettura*, 1926, oil on canvas, 36 x 28in. Early and Late De Chirico works have inspired a generation of Post-Modern architects such as Aldo Rossi and Leon Krier and artists such as Gerard Garouste and Stephen McKenna. The appeal of his enigmatic allegories lies perhaps in their portrayal of a lost, classical world; a dignified image of man, nature and architecture set in quixotic disruption. Many other Modern artists – Picasso, Moore, Balthus, Morandi, Magritte – have had an equal influence on Post-Modernists and thus one can speak of an evolution from, as well as a contrast between, the two periods. (Courtesy of Robert Miller Gallery, New York)

I THE PROTESTANT INQUISITION

In October 1981 *Le Monde* announced to its morning readers, under the section of its newspaper ominously headed 'Décadence', that a spectre was haunting Europe, the spectre of Post-Modernism.[10] What Frenchmen made of this warning as they bit into their croissants is anybody's guess, especially as it came with the familiar Marxist image of a ghost looming over their civilisation (and their coffee) – but they probably soon forgot the phantom and looked forward to next morning's 'Décadence' column, for in our culture one ghost grows boring and must be quickly replaced by the next. The problem, however, has been that critics – especially hostile, Modernist critics – won't let this one dissolve. They keep attacking the phantom with ever-increasing hysteria, making it grow into quite a substantial force that upsets not only *le petit déjeuner* but also international conferences and price quotations on the international art market. If they aren't careful, there will be a panic and crash at the Museum of Modern Art as certain reputations dissolve like dead stock.

Clement Greenberg, long acknowledged as the theorist of American Modernism, defined Post-Modernism in 1979 as the antithesis of all he loved: that is, as the lowering of aesthetic standards caused by 'the democratization of culture under industrialism.'[11] Like our 'Décadence' columnist he saw the danger as a lack of hierarchy in artistic judgement, although he didn't go so far as the Frenchman in calling it simply 'nihilism'. Another art critic, Walter Darby Bannard, writing in the same prestigious *Arts Magazine* five years later, continued Greenberg's crusade against the heathens and re-stated the same (non) definition, except with more brutal elaboration: 'Postmodernism is aimless, anarchic, amorphous, self-indulgent, inclusive, horizontally structured, and aims for the popular.'[12] Why did he leave out 'ruthless kitsch' or the standard comparison with Nazi populism that the architectural critic Ken Frampton always adds to the list of horrors? Ever since Clement Greenberg made his famous opposition between 'Avant-Garde and Kitsch' in a 1939 article, certain puritanical intellectuals have been arguing that it has to be one thing or the other, and it's clear where they classify Post-Modernism, although of course if it's really 'horizontally structured' and 'democratic' it can't

10 Gérard-Georges Lemaire, 'Le Spectre du post-modernisme', 'Décadence', *Le Monde Dimanche*, 18 October 1981, p. XIV.

11 Clement Greenberg, 'Modern and Post-Modern' – presented at the fourth Sir William Dobell Memorial Lecture in Sydney, Australia, on 31 October 1979 and published the following year in *Arts Magazine*.

12 Walter Darby Bannard, 'On Postmodernism', an essay originally presented at a panel on Post-Modernism at the Modern Languages Association's annual meeting in New York, 28 December 1983, published later in *Arts Magazine*.

13 Aldo van Eyck, 'RPP – Rats, Posts and Other Pests', 1981 RIBA Annual Discourse published in *RIBA Journal, Lotus* and most fully in *AD News*, 7/81, London 1981, pp. 14-16.

be at the same time Neo-Nazi and authoritarian. But consistency has never been a virtue of those out to malign a movement.

Quite recently the Royal Institute of British Architects (RIBA) has been hosting a series of revivalist meetings which are noteworthy for their vicious attacks on Post-Modernism. In 1981 the Dutch architect Aldo van Eyck delivered the Annual Discourse titled 'Rats, Posts and Other Pests', and one can guess from this appellation how hard he attempted to be fair-minded. He advised his cheering audience of Modernists in a capital-lettered harangue, 'Ladies and Gentlemen, I beg you, HOUND THEM DOWN AND LET THE FOXES GO' – tactics not unlike the Nazi ones he was deploring, although the hounds and foxes give this pogrom an Oscar Wilde twist.[13] If Van Eyck advised letting the dogs loose on Post-Modernists, the older Modern architect Berthold Lubetkin limited himself, on receiving his Gold Medal at the RIBA, to classing them with homosexuals, Hitler and Stalin: 'This is a transvestite architecture, Heppelwhite and Chippendale in drag.'[14] And he continued to compare Post-Modernism with Nazi kitsch in subsequent revivalist *soirées* in Paris and at the RIBA, even equating Prince Charles with Stalin for his attack on Modernism.[15] One could quote similar abuse from old-hat Modernists in America, Germany, Italy, France, indeed most of the world. For instance the noted Italian critic Bruno Zevi sees Post-Modernism as a 'pastiche . . . trying to copy Classicism' and 'repressive' like fascism.[16]

We can see in all these howls of protest something like a negative definition emerging, a paranoic definition made by Modernists in retreat trying to hold the High Church together, issuing daily edicts denouncing heresy, keeping the faith among ever-dwindling numbers. It is true they still control most of the academies, sit on most of the aesthetic review boards, and repress as many Post-Modern artists and architects as they can, but the mass of young professionals have fled from the old Protestant orthodoxy and are themselves bored and fed up with the taboos and suppressions. In any international competition now more than half the entries will be Post-Modern, and that generality applies as much to sculpture and painting as it does to architecture. The door is wide open, as it was in the 1920s when Modernism had knocked down the previous academic barriers; the irony is that today's old-time Modernists are determined to be just as

14 Berthold Lubetkin, 'Royal Gold Medal Address', RIBA, *Transactions* II, Vol. 1, No. 2, London 1982, p. 48.

15 Berthold Lubetkin, 'RIBA President's Invitation Lecture', 11 June 1985, unpublished manuscript, p. 13. Published in part in *Building Design Magazine*, London. The comparison is with Stalin's giving Corinthian columns to the people. The Prince of Wales provokes the following memory: 'I can't help recalling the diktat of Stalin fifty years ago when he said "The assumption that the specialists know better drags theory and practice into the bog of reactionary cosmopolitan opinion." The proletariat acquired the right to have their Corinthian colonnades. . . '

16 'Is Post-Modern Architecture Serious?': Paolo Portoghesi and Bruno Zevi in Conversation', *Architectural Design*, 1/2 1982, pp. 20-1, originally published in Italian in *L'Espresso*.

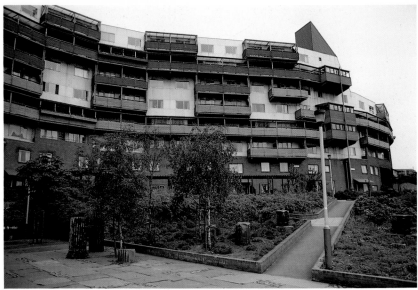

[4] Ralph Erskine, Byker Wall, Newcastle, 1974. Some of the first Post-Modern housing was *ad hoc* and vernacular in style making use, as here, of traditional and modern materials, green stained wood, brick, corrugated metal and asbestos. Also, following the Team Ten critique of the *tabula rasa*, it tended to mix high and low buildings with existing ones. Classical fragments are also incorporated in this collage. The emphasis on participation, with design acknowledging the tastes of the inhabitants, has remained a constant social goal of Post-Modernists. Ralph Erskine, Vernon Gracie and the architects actually had their office accessible on the site. (Photo C. Jencks)

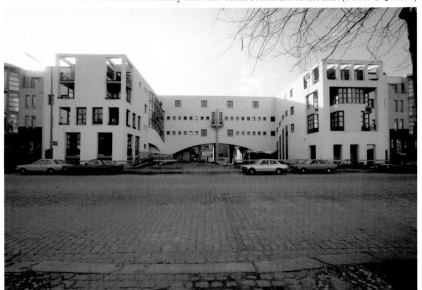

[5] Robert Krier, Ritterstrasse Apartments, Berlin-Kreuzberg, 1977-81. The white social housing of the Modernists is here adapted in a palazzo U-shaped block to form part of a perimeter block and positive urban space. Modern technology and imagery is mixed with a traditional typology, a typical double coding. Subsequently Robert Krier and others have been instrumental in the development of Post-Modern housing in Berlin under the auspices of the IBA. The typologies are exemplary, as is the idea of having several architects work together with common guidelines: by 1987 the results of this new urbanism can be gauged. (Photo Gerald Blomeyer)

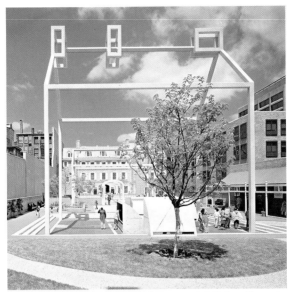

[6] Venturi and Rauch, Franklin Court, Philadelphia, 1972-6. Robert Venturi and Denise Scott Brown took up the lessons of Pop art and applied them to a Las Vegas study generalising such rhetorical devices as the amplification of image and stereotype. The goal was a legible architecture understood in a mass-culture. Here Benjamin Franklin's house is 'ghosted' in stainless steel, a Pop icon of the past set above his preserved memorabilia and sayings on plaques. (Photo Venturi and Rauch)

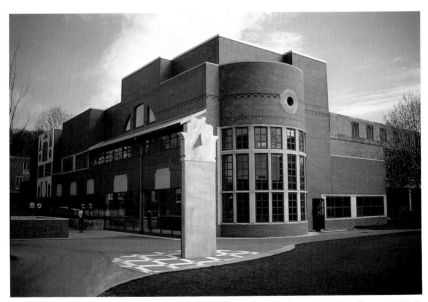

[7] Venturi Rauch and Scott Brown, Gordon Wu Dining Hall, Princeton, New Jersey, 1981-3. Along with James Stirling's Neue Staatsgalerie and Michael Graves' Humana Building this work ranks as one of the first mature buildings of Post-Modernism. Built in a Free-Style Classicism that is appropriate to the Princeton campus, it uses Modern elements, such as the strip window, and traditional signs, such as the Serliana, in a functional, symbolic and ironic manner. The 'complexity and contradiction' and other rhetorical devices which Venturi espoused in the 1960s are present, but not overly insistent. (Photo C. Jencks)

13

paranoic, reactionary and repressive as their Beaux-Arts persecutors were before them. Indeed the slurs against Post-Modernists occasionally sound like the Nazi and academic vitriol poured on Le Corbusier and Walter Gropius in the 1920s. Is history repeating itself in reverse? I'm not sure, but I do believe that these characterisations have not done what they were supposed to do – stem the tide of Post-Modernism – but rather have helped blow it up into a media event. My nightmare is that suddenly the reactionaries will become nice and civil. Everyone, but particularly the press, loves an abusive argument carried on by professors and the otherwise intelligent: it's always entertaining even if it obscures as much as it explains. And what it has hidden are the root causes of the movement.

II POST-MODERNISM DEFINED

Post-Modernism, like Modernism, varies for each art both in its motives and time-frame, and here I shall define it just in the field with which I am most involved – architecture. The responsibility for introducing it into the architectural subconscious lies with Joseph Hudnut who, at Harvard with Walter Gropius, may have wished to give this pioneer of the Modern Movement a few sleepless nights. At any rate, he used the term in the title of an article published in 1945 called 'the post-modern house' (all lower case, as was Bauhaus practice), but didn't mention it in the body of the text or define it polemically. Except for an occasional slip here and there, by Philip Johnson or Nikolaus Pevsner, it wasn't used until my own writing on the subject which started in 1975.[17] In that first year of lecturing and polemicising in Europe and America, I used it as a temporising label, as a definition to describe where we had left rather than where we were going. The observable fact was that architects as various as [4-7] Ralph Erskine, Robert Venturi, Lucien Kroll, the Krier brothers and Team Ten had all departed from Modernism and set off in different directions which *kept a trace of their common departure*. To this day I would define Post-Modernism as I did in 1978 as *double coding: the combination of Modern techniques with something else (usually traditional building) in order for architecture to communicate with the public and a concerned minority, usually other architects*. The point of this double coding was itself double. Modern architecture had failed to remain credible partly because it didn't communicate effectively with its ultimate users – the main argument of my book *The Language of Post-Modern Architecture* – and partly because it didn't make effective links with the city and history. Thus the solution I perceived and defined as Post-Modern: an architecture that was

17 My own writing and lecturing on Post-Modernism in architecture started in 1975 and 'The Rise of Post-Modern Architecture' was published in a Dutch book and a British magazine, *Architecture – Inner Town Government*, Eindhoven, July 1975, and *Architecture Association Quarterly*, No. 4, 1975. Subsequently Eisenman and Stern started using the term and by 1977 it had caught on. For a brief history see the 'Footnote on the Term' in *The Language of Post-Modern Architecture*, fourth edition, Academy Editions, London/Rizzoli, New York 1984, p. 8.

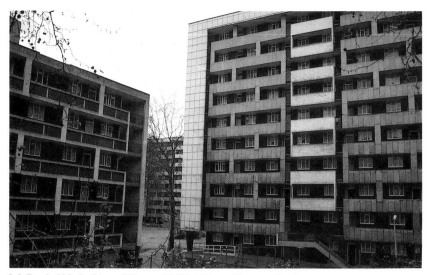

[8] Berthold Lubetkin and Tecton, Hallfield Estate Housing, London, 1947-55. The typology of Le Corbusier's 'City in the Park' led to an urbanism which was first criticised by Jane Jacobs in 1961 and then later by a chorus of writers including Robert Goodman, Oscar Newman, Rob Krier, Colin Ward and, recently, Alice Coleman. Lack of personal 'defensible space' represents just one of the problems of this typology; scale, density, and symbolism are equally questionable. (Photo C. Jencks)

professionally based *and* popular as well as one that was based on new techniques *and* old patterns. Double coding to simplify means both elite/popular and new/old and there are compelling reasons for these opposite pairings. Today's Post-Modern architects were trained by Modernists, and are committed to using contemporary technology as well as facing current social reality. These commitments are enough to distinguish them from revivalists or traditionalists, a point worth stressing since it creates their hybrid language, the style of Post-Modern architecture. The same is not completely true of Post-Modern artists and writers who may use traditional techniques of narrative and representation in a more straightforward way. Yet all the creators who could be called Post-Modern keep something of a Modern sensibility – some intention which distinguishes their work from that of revivalists – whether this is irony, parody, displacement, complexity, eclecticism, realism or any number of contemporary tactics and goals. As I mentioned in the foreword, Post-Modernism has the essential double meaning: the continuation of Modernism and its transcendence.

The main motive for Post-Modern architecture is obviously the social failure of Modern architecture, its mythical 'death' announced repeatedly over ten years. In 1968, an English tower block of housing, Ronan Point, suffered what was called 'cumulative collapse' as its floors gave way after an explosion. In 1972, many slab blocks of housing were intentionally blown up at Pruitt-Igoe in St Louis. By the mid 1970s, these explosions were becoming a quite frequent method of dealing with the failures of Modernist building methods: cheap [8]

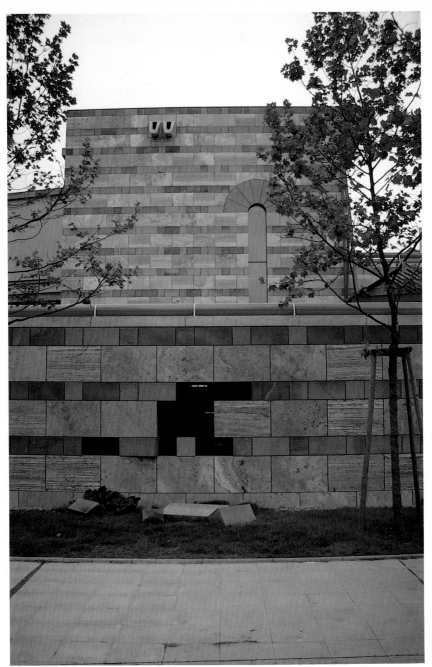

[9] James Stirling Michael Wilford and Associates, Neue Staatsgalerie, Stuttgart, 1977-84. 'Ruins in the Garden', classical blocks which have fallen about in an eighteenth-century manner, reveal the reality of Post-Modern construction: a steel frame holds up the slabs of masonry, and there is no cement between the blocks, but rather air. These holes in the walls, which are ironic vents to the parking garage, dramatise the difference between truth and illusion, and allow Stirling to assert continuity with the existing classical fabric while also showing the differences. Paradox and double coding exist throughout this scheme, which is more an articulation of urban tissue than a conventional building. (Photo C. Jencks)

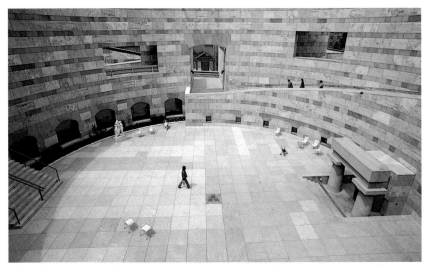

[10] Neue Staatsgalerie. The sculpture court, a transformation of the Pantheon and Hadrian's Villa among other classical types, is a true *res publica* with the public brought through the site on a curvilinear walkway to the right. Cut off from traffic and noise it also combines the profane piazza, reminiscent of De Chirico, with the sacred space of a centralised church. The oppositions continue with rustication set against metallic handrails, a sunken Doric portico opposed to an orange revolving door, and an implied ruin versus picture windows. Traditional and Modern 'language games' are not synthesised but rather juxtaposed in tension, an allegory of a schizophrenic culture. (Photo C. Jencks)

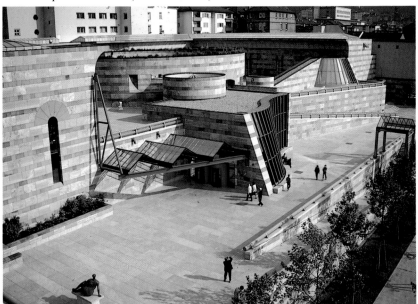

[11] Neue Staatsgalerie. The 'Acropolis' perched on a garage shows further aspects of the discontinuous pluralism which J.F. Lyotard and others see as a defining aspect of Post-Modernism. Stirling has described the major opposition between informal and monumental elements, change and stasis, through colourful steel shapes set against a classical background. Oddly the role of ornament is taken on by Modernist forms: function by traditional ones. This ironic reversal of twentieth-century convention implies a new set of standards which throws in doubt both Neo-Classical and Modern aesthetics. (Photo C. Jencks)

prefabrication, lack of personal 'defensible' space and the alienating housing estate. The 'death' of Modern architecture and its ideology of progress which offered technical solutions to social problems was seen by everyone in a vivid way. The destruction of the central city and historical fabric was almost equally apparent to the populace and again these popular, social motives should be stressed because they aren't quite the same in painting, film, dance or literature. There is no similar, vivid 'death' of Modernism in these fields, nor perhaps the same social motivation that one finds in Post-Modern architecture. But even in Post-Modern literature there is a social motive for using past forms in an ironic way. Umberto Eco has described this irony or double coding: 'I think of the postmodern attitude as that of a man who loves a very cultivated woman and knows he cannot say to her, "I love you madly." because he knows that she knows (and that she knows that he knows) that these words have already been written by Barbara Cartland. Still, there is a solution. He can say, "As Barbara Cartland would put it, I love you madly". At this point, having avoided false innocence, having said clearly that it is no longer possible to speak innocently, he will nevertheless have said what he wanted to say to the woman: that he loves her, but he loves her in an age of lost innocence. If the woman goes along with this, she will have received a declaration of love all the same. Neither of the two speakers will feel innocent, both will have accepted the challenge of the past, of the already said, which cannot be eliminated, both will consciously and with pleasure play the game of irony . . . But both will have succeeded, once again, in speaking of love.'[18]

Thus Eco underlines the lover's use of Post-Modern double coding and extends it, of course, to the novelist's and poet's social use of previous forms. Faced with a restrictive Modernism, a minimalism of means and ends, writers such as John Barth have felt just as restricted as architects forced to build in the International Style, or using only glass and steel. The most notable, and perhaps the best, use of this double coding in architecture is James Stirling's addition to the Staatsgalerie in Stuttgart. Here one can find the fabric of the city and the existing museum extended in amusing and ironic ways. The U-shaped palazzo form of the old gallery is echoed and placed on a high plinth, or 'Acropolis', above the traffic. But this classical base holds a very real and necessary parking garage, one that is ironically [9] indicated by stones which have 'fallen', like ruins, to the ground. The resultant holes show the real construction – not the thick marble blocks of the real Acropolis, but a steel frame holding stone cladding which allows the air ventilation required by law. One can sit on these false ruins and ponder the truth of our lost innocence: that we live in an age which can build with beautiful, expressive masonry as long as we make it skin-deep and hang it on a steel skeleton. A Modernist

18 Umberto Eco, *Postscript to The Name of the Rose*, Harcourt Brace Jovanovich, New York 1984, pp. 67-8.

would of course deny himself and us this pleasure for a number of reasons: 'truth to materials', 'logical consistency', 'straightforward-ness', 'simplicity' – all the values and rhetorical tropes celebrated by such Modernists as Le Corbusier and Mies van der Rohe.

Stirling, by contrast and like the lovers of Umberto Eco, wants to communicate more and different values. To signify the permanent nature of the museum, he has used traditional rustication and classical forms including an Egyptian cornice, an open-air Pantheon, [10] and segmental arches. These are beautiful in an understated and conventional way, but they aren't revivalist either because of small distortions, or the use of a modern material such as reinforced concrete. They say, 'We are beautiful like the Acropolis or Pantheon, but we are also based on concrete technology and deceit.' The extreme form of this double coding is visible at the entry points: a steel temple outline which announces the taxi drop-off point, and the Modernist steel canopies which tell the public where to walk in. These [11] forms and colours are reminiscent of De Stijl, that quintessentially modern language, but they are collaged onto the traditional back-ground. Thus Modernism confronts Classicism to such an extent that both Modernists and Classicists would be surprised, if not offended. There is not the simple harmony and consistency of either language or world view. It's as if Stirling were saying through his hybrid language and uneasy confrontations that we live in a complex world where we can't deny either the past and conventional beauty, or the present and current technical and social reality. Caught between this past and present, unwilling to oversimplify our situation, Stirling has pro-duced the most 'real' beauty of Post-Modern architecture to date.

As much of this reality has to do with taste as it does with technology. Modernism failed as mass-housing and city building partly because it failed to communicate with its inhabitants and users who might not have liked the style, understood what it meant or even known how to use it. Hence the double coding, the essential definition of Post-Modernism, has been used as a strategy of communicating on various levels at once. Virtually every Post-Modern architect – Robert Venturi, Hans Hollein, Charles Moore, Robert Stern, Michael Graves, Arata Isozaki are the notable examples – use popular *and* elitist signs in their work to achieve quite different ends, and their styles are essentially hybrid. To simplify, at Stuttgart the blue and red handrails and vibrant polychromy fit in with the youth that uses the museum – they literally resemble their dayglo hair and anoraks – [12] while the Classicism appeals more to the lovers of Schinkel. This is a very popular building with young and old and when I interviewed people there – a group of *plein air* painters, schoolchildren and businessmen – I found their different perceptions and tastes were accommodated and stretched. The pluralism which is so often called on to justify Post-Modernism is here a tangible reality.

This is not the place to recount the history of Post-Modern

[12] Neue Staatsgalerie. The taxi drop-off point is emphasised by a large steel canopy, a foursquare 'primitive hut' made from the typical Doric of our time, the I-beam. The architecture draws in quite different media: handrails are continuously used as slides and colourful anoraks and clothing seem a part of the design. With this scheme the philosophy of 'collage city' reaches both a culmination and crisis point: what is the scenario which makes sense of these juxtapositions? (Photo C. Jencks)

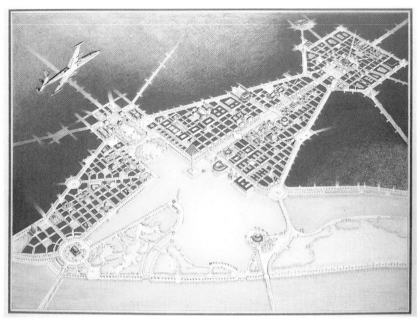

[13] Leon Krier, *The Completion of Washington DC*, 1985, aerial perspective. L'Enfant's Baroque plan of Washington is finally filled out and given the fabric which the monuments so desperately need. Four large towns, based on a traditional typology of small blocks, give the density and measure to urban life which Modernist schemes have lost. It looks nostalgic at first and then one realises that the relation between parts – monument and infill, courtyard and street, living and work areas – is an optimum achieved in few periods; with the Roman castrum and occasionally in the Renaissance and eighteenth-century France. Krier's use of the past to challenge the present – especially the suburban, agoraphobic present that is Washington DC – is as pertinent as his notion of the 'Masterplan as Constitution'. And it's far better than Le Corbusier's notion of the 'Plan as Dictator'. (Courtesy of Leon Krier)

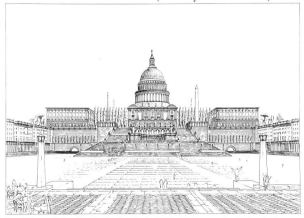

[14] Leon Krier, *View of the Nation's Capitol*, 1985. This megabuilding is 'improved' by being brought down to the ground by flights of steps which anchor it in a public piazza, and by being broken up into grammatical parts. The wings are now visually separated from the centre by planting and so do not form a run-on sentence. This Corbusian perspective, taken from his typical Parisian terrace with outdoor cafe, invests Washington with a much-needed urbanity. Although the arcades to either side are not being built, Jaquelin Robertson, an urbanist sympathetic to Krier, has recently completed one block near the Capitol which shows the virtues of this typology. (Courtesy of Leon Krier)

architecture, but I want to stress the ideological and social intentions which underlie this history because they are so often overlooked in the bitter debate with Modernists.[19] Even traditionalists often reduce the debate to matters of style, and thus the symbolic intentions and morality are overlooked. If one reads the writings of Robert Venturi, Denise Scott Brown, Christian Norberg-Schulz, or myself, one will find the constant notion of pluralism, the idea that the architect must design for different 'taste cultures' (in the words of the sociologist Herbert Gans) and for differing views of the good life. In any complex building, in any large city building such as an office, there will be varying tastes and functions that have to be articulated and these will inevitably lead, if the architect follows these hints, towards an eclectic style. He may pull this heterogeneity together under a Free-Style Classicism, as do many Post-Modernists today, but a trace of the pluralism will and should remain. I would even argue that 'the true and proper style' is not as they said Gothic, but some form of eclecticism, because only this can adequately encompass the pluralism that is our social and metaphysical reality.

Many people would disagree with this last point and some of them, such as the visionary and urbanist Leon Krier, are almost Post-Modern. I bring him up as a borderline case and because he shows how different traditions may influence each other in a positive way. Krier worked for James Stirling in the early 1970s and since then has [13] evolved his own form of Vernacular Classicism. In his schemes for the reconstruction of cities such as Berlin and Washington DC, he shows how the destroyed fabric of the historic city could be repaired and a traditional set of well-scaled spaces added to this core. The motivations are urbanistic and utopian (in the sense that they are unlikely to be realised). They are also traditional and idealistic in the straightforward manner that Post-Modernism is not. The way of life implied is paternalistic and monistic, but the plans would entail not the totalitarianism that his critics aver when they compare him with Albert Speer but an integrated culture led by a determined and sensitive elite. In this sense, Krier hasn't lost the innocence which Umberto Eco and the Post-Modernists believe is gone for good, but has returned to a pre-industrial golden age where singular visions could be imagined for everyone. Again, critics will say he's kept his innocence precisely because he hasn't built and faced the irreducibly plural reality.

19 Besides my own *The Language of Post-Modern Architecture*, op. cit., *Current Architecture*, Academy Editions, London/Rizzoli, New York 1982, and *Modern Movements in Architecture*, second edition, Penguin Books, Harmondsworth, 1985, see Paolo Portoghesi, *After Modern Architecture*, Rizzoli, New York 1982, and its updated version, *Postmodern*, Rizzoli, New York 1983, and *Immagini del Post-Moderno*, Edizioni Chiva, Venice 1983. See also Heinrich Klotz, *Die Revision der Moderne, Postmoderne Architektur, 1960-1980* and *Moderne und Postmoderne Architektur der Gegenwart 1960-1980*, Friedr. Vieweg & Sohn, Braunschweig/Wiesbaden 1984. We have debated his notion of Post-Modern architecture as 'fiction' and this has been published in *Architectural Design* 7/8 1984, *Revision of the Modern*. See also my discussion of users and abusers of Post-Modern in 'La Bataille des étiquettes', *Nouveaux plaisirs d'architecture*, Centre Georges Pompidou, Paris 1985, pp. 25-33.

This may be true and yet Krier has had a beneficent effect on Post-Modernists, as on others, because his ideal models act as a critique of current planning in the same way as do such surviving fragments as the centres of Siena and Venice. His nostalgia, like that of the French Revolution, is of a very positive and creative kind because it shows what a modern city might be if built with traditional streets, arcades, lakes and squares. Moreover – and this does make [14] him a Post-Modernist – his drawing manner, derived equally from Le Corbusier and the École des Beaux-Arts, is based on practical urban knowledge. He is not simply a mannerist, sprinkling bi-planes and 1920s technology through the sky, but someone who thinks through all the public buildings and private fabric before he draws. His bi-planes are of course ironic Post-Modern comments on the desirability of technical regression.

There are, inevitably, many more strands of Post-Modern architecture than the two major ones which the work of Stirling and Krier represent, and I have tried to show the plurality as consisting of six basic traditions or 'species'. There is some overlap between these identifiable species, within the evolutionary tree of my diagram, and architects, unlike animals, can jump from one category to another, or [19] occupy several strands at once. The diagram shows two fundamental aspects which have to be added to our former definition of Post-Modernism: it is a movement that starts *roughly in 1960 as a set of plural departures from Modernism*. Key definers are a pluralism both philosophical and stylistic, and a dialectical or critical relation to a pre-existing ideology. There is no one Post-Modern style, although there is a dominating Classicism, just as there was no one Modern mode, although there was a dominating International Style. Furthermore, if one is going to classify anything as complex as an architectural movement, one has to use *many* definers: Anthony Blunt, in a key text on Baroque and Rococo, shows the necessity for using ten definers, and in distinguishing Post-Modernism from Modern and Late-Modern architecture, I have used thirty.[20] Most of these definers concern differences over symbolism, ornament, humour, technology and the relation of the architect to existing and past cultures. Modernists and Late-Modernists tend to emphasise technical and economic solutions to problems, whereas Post-Modernists tend to emphasise contextual and cultural additions to their inventions.

Many of these points could be made about Post-Modern art. It also started roughly in 1960 with succession of departures from Modernism – notably Pop Art, Hyperrealism, Photo Realism, Allegorical and Political Realism, New Image Painting, *La Transavanguardia*, Neo-Expressionism and a host of other more or less fabricated movements. Pressure from the art market to produce new labels and synthetic

20 Anthony Blunt, *Some Uses and Misuses of the Terms Baroque and Rococo as applied to Architecture*, Oxford 1973; Charles Jencks, *Late-Modern Architecture*, Academy Editions, London/Rizzoli, New York 1980, p. 32.

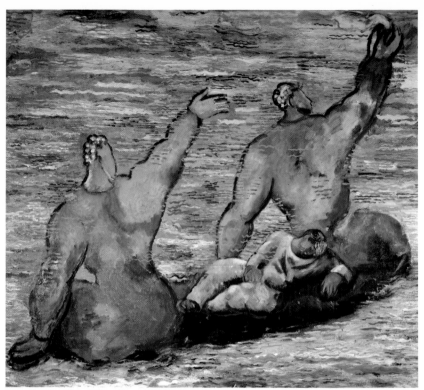

[15] Sandro Chia, *Three Boys on a Raft*, 1983, oil on canvas, 97 x 111in. The re-use of Italian Futurist and mythological themes and techniques, borrowing freely from Mediterranean traditions which are chosen and combined for their secondary meanings. (Zindman/Fremont, Paine Weber Inc. Courtesy of Leo Castelli Gallery, New York)

[16] Carlo Maria Mariani, *Costellazioni del Leone (La Scuola di Roma)*, 1980-1, oil on canvas, 133⅞ x 177⁹/₁₆in. An elaborate allegory on the current Post-Modern School of Rome – one part eighteenth-century pastiche, one part critical satire. (Courtesy of Sperone Westwater Gallery, New York)

[17] Eric Fischl, *A Brief History of North Africa*, 1985, oil on linen, 88 x 120in. Fischl explores archetypal scenes – the beach, the suburban backyard, the bedroom – for their latent violence and sexuality. The atmosphere is often charged with a dissociated passion that reveals the vulnerability of character and the ambiguity of political and social roles. (Courtesy of Mary Boone Gallery, New York)

[18] Ron Kitaj, *If Not, Not*, 1975-6, oil on canvas, 60 x 60in. The most serious Post-Modern painter often uses Modernist themes and characters as a departure point for his fractured allegories. These sustain a mood of catastrophe and mystery which is alleviated by small emblems of hope and a haunting beauty. (Courtesy of Scottish National Gallery of Modern Art)

[19] Evolutionary Tree of Post-Modern Architecture, 1960-1980. In any major movement there are various strands running concurrently which have to be distinguished because of differing values. Here the six main traditions of Post-Modernism show their common ground and differences and illustrate the fact that since the late 1970s Post-Modern Classicism and urbanism have been unifying forces.

schools has, no doubt, increased the tempo and heat of this change. And the influence of the international media, so emphasised as a defining aspect of the post-industrial society, has made these movements cross over national boundaries. Post-Modern art, like architecture, is influenced by the 'world village' and the sensibility that comes with this: an ironic cosmopolitanism. If one looks at three Italian Post-Modernists, Carlo Maria Mariani, Sandro Chia and [15] Mimmo Paladino, one sees their 'Italianess' always in quotation marks, an ironic fabrication of their roots made as much for the New York they occasionally inhabit as from inner necessity. Whereas a mythology was given to the artist in the past by tradition and by patron, in the Post-Modern world it is chosen and invented.

Mariani, in the mid 1970s, created his fictional academy of eighteenth-century peers – Goethe, Winckelmann, Mengs, etc – and then painted some missing canvasses to fill out a mythic history. In the early 1980s he transferred this mythology to the present day and painted an allegory of Post-Modern Parnassus with friends, enemies, [16] critics and dealers collected around himself in the centre – a modern-day version of Raphael's and Meng's versions of the traditional subject. We see here a series of texts layered one on top of another as an enigmatic commentary, like the structure of a myth. Is it serious, or parody, or more likely, the combination ironic allegory? The facial expressions and detail would suggest this double reading. Mariani both solemn and supercilious sits below Ganymede being abducted to heaven by Zeus: Ganymede is not only the beautiful boy of Greek mythology being captured in the erotic embrace of the eagle Zeus, but a portrait of the performance artist Luigi Ontani, hence the hoop and stick. To the right, Francesco Clemente gazes past a canvas held by Sandro Chia; Mario Merz is Hercules in an understated bathtub; a well-known New York dealer waddles to the water personified as a turtle; critics write and admire their own profiles. All this is carried out in the mock heroic style of the late eighteenth century, the style of *la pittura colta* which Mariani has made his own. No one who gives this 'cultured painting' an extended analysis would call it eighteenth-century, or straight revivalist, although many critics unsympathetic to Post-Modernism have again branded the work as 'fascist'. The representational conventions had been dismissed by Modernists as taboo, as frigid academic art.

If Mariani adapts and invents his mythology then so do many Post-Modernists who are involved in allegory and narrative. This concern for content and subject matter is in a sense comparable to architects' renewed concern for symbolism and meaning. Whereas Modernism and particularly Late-Modernism concentrated on the autonomy and expression of the individual art form – the aesthetic dimension – Post-Modernists focus on the semantic aspect. This generalisation is true of such different artists as David Hockney, Malcolm Morley, Eric Fischl, Lennart Anderson and Paul Georges, [17]

27

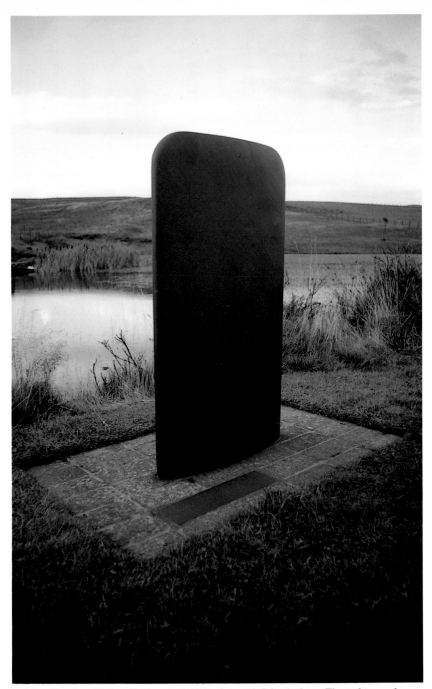

[20] Ian Hamilton Finlay, *Nuclear Sail*, 1974, slate with John Andrew. The ambiguous beauty of war machines is often a departure point for Finlay's combination of emblem, writing and sculpture. Here the black 'sail' of a Polaris submarine stands against an artificial lake with the title engraved beside it: the ambiguity of the sail/coning tower is thus extended to that of a dolmen and black tombstone. Terror and virtue, destruction and beauty, are two sides to Finlay's art as in military iconography. (Photo C. Jencks)

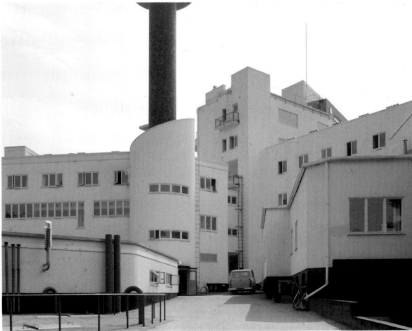

[21] Alvar Aalto, Tuberculosis Sanatorium, Paimio, Finland, 1933. The most appropriate and successful use of the International Style was on hospitals and occasionally, in Germany, Finland and Switzerland, on workers' housing. With its open-air communal block set amid the pine trees giving the patients salubrious views of nature, and its careful detailing and construction, the Paimio Sanatorium has turned institutional imagery into a heroic reality. (Photos D. Porphyrios)

some of whom have painted enigmatic allegories, others a combination of sexual and classical narratives. The so-called 'return to painting' of the 1980s is also a return to a traditional concern with content, although it is content with a difference from pre-Modern art.

First, because these Post-Modernists have had a Modern training, they are inevitably concerned with abstraction and the basic reality of modern life, that is, a secular mass-culture dominated by economic and pragmatic motives. This gives their work the same complexity, mannerism and double coding present in Post-Modern architecture, [18] and also an eclectic or hybrid style. For instance Ron Kitaj, who is the artist most concerned with literary and cultural subject matter, combines Modernist techniques of collage and a flat, graphic composition with Renaissance traditions. His enigmatic allegory *If Not, Not* is a visual counterpart of T.S. Eliot's *The Wasteland*, on which it is partly based. Survivors of war crawl through the desert towards an oasis, survivors of civilisation (Eliot himself) are engaged in quizzical acts, some with representatives of exotic culture. Lamb, crow, palm tree, turquoise lake, and a Tuscan landscape consciously adapted from the classical tradition resonate with common overtones. They point towards a western and Christian background overlaid by Modernism, the cult of primitivism and disaster. The classical barn/monument at the top, so reminiscent of Aldo Rossi and Post-Modern face buildings, also suggests the death camps, which it represents. Indeed the burning inferno of the sky, the corpse and broken pier, the black and truncated trees all suggest life after the Second World War: plural, confused and tortured on the whole, but containing islands of peace (and a search for wholeness). The title, with its double negative – *If Not, Not* – was taken from an ancient political oath which meant roughly: if you the King do not uphold our liberties and laws, then we do not uphold you. Thus the consequences of broken promises and fragmented culture are the content of this gripping drama, one given a classical *gravitas* and dignity.

Examples could be multiplied of this type of hidden moralistic narrative: Robert Rauschenberg, David Salle, Hans Haacke, Ian [20] Hamilton Finlay and Stephen McKenna all make use of the classical tradition in portraying our current cultural situation. Their political and ethical views are often opposed, but their intention to revive the tradition of moralistic art is shared. Thus the definition of Post-Modernism that I've given above for architects also holds true for artists and, I believe, such literary figures as Umberto Eco, David Lodge, John Barth, John Gardner and Jorge Luis Borges among many others. It does not hold true, however, for so many artists lumped together under a Post-Modern label for whom there are much better appellations.

III MODERN AND LATE-MODERN DEFINED

The Modern Movement, as I've suggested, was in architecture a Protestant Reformation putting faith in the liberating aspects of industrialisation and mass-democracy. Le Corbusier pursued his 'crusade', as he called it, for 'a new spirit', as he also called it, and his reformed religion was meant to change the public's attitude towards mass-production. So convinced was this prophet of the beneficent effects of a well-designed environment that he ended his bible – *Towards a New Architecture* – with the exhortation: 'Architecture or Revolution. Revolution can be avoided.' Walter Gropius, another militant saint of the Design Reformation, founded the Bauhaus as a 'cathedral of the future' and in 1923 declared the standard doctrine: 'art and technology: a new unity'. Mies van der Rohe made any number of pleas to the Spirit of the Age, the *Zeitgeist* of the new industrialisation, and proclaimed that it could solve all our problems, even 'social, economic and artistic' ones.[21]

In short, the three leading Modern architects didn't just practise a common, Protestant style, but also believed that if their faith were to govern industrialisation then it could change the world for the better, both physically and spiritually. This religion of Modernism triumphed throughout the globe as it was disseminated by the saints and proselytisers – Sir Nikolaus Pevsner, Sir James Richards, Sir Leslie Martin, with the bible according to Siegfried Giedion, *Space, Time and Architecture*. Modern academies were formed at the major universities such as Cambridge and Harvard and from there the Purist doctrines of John Calvin Corbusier, Martin Luther Gropius and John Knox van der Rohe were dispersed. Their white cathedrals, the black and white boxes of the International Style, were soon built in every land, and for a while the people and professors kept the faith. Ornament, polychromy, metaphor, humour, symbolism and convention were put on the Index and all forms of decoration and historical reference were declared taboo. We are all well acquainted with the results – 'the architecture of good intentions' – as Colin Rowe termed them, and there are a lot of pleasant white housing estates and machine-aesthetic hospitals to prove that the intentions were not all [21] misguided.

The reigning religion of architectural Modernism could be called pragmatic amelioration, that is the belief that by 'doing more with less' as Buckminster Fuller said, social problems would slowly disappear. Technical progress, in limited spheres such as medicine, seems to bear out this ideology, still a dominant one of Late-Modernists.

Thus we might define Modern architecture as the *universal, international style stemming from the facts of new constructional*

21 Ludwig Mies van der Rohe, 'Industrialized Building', 1924, reprinted in *Programmes and Manifestoes on 20th-Century Architecture*, Lund Humphries, London 1970, p. 81.

means, adequate to a new industrial society, and having as its goal the transformation of society, both in its taste and social make-up. But there is an anomaly in this Modernism which is both overwhelming and missed by commentators on the subject. It is the direct opposite of the more widespread Modernism in the other arts and philosophy; for these are *not* optimistic and progressivist at all. Think of Nietzsche, Goedel, Heisenberg, Heidegger and Sartre – closer to nihilism than to the positivism of Fuller. Or think of Yeats, Joyce, Pound, T.S. Eliot, or De Chirico, Picasso, Duchamp and Grosz – hardly liberal, not very socialist and certainly not optimistic. Whereas Modernism in architecture has furthered the ideology of industrialisation and progress, Modernism in most other fields has either fought these trends or lamented them. In two key areas, however, the various Modernisms agree and that is over the value of abstraction and the primary role of aesthetics, or the perfection of the expressive medium. Modernism as Clement Greenberg has defined it always has this irreducible goal: to focus on the essence of each art language. By doing this, he argues, standards are kept high in an age of secularisation, where there are few shared values and little left of a common symbolic system. All one can do in an agnostic age of consumer pluralism is sharpen the tools of one's trade, or 'purify the language of the tribe', as Mallarmé and T.S. Eliot defined the poet's role.

This idea relates closely to the nineteenth-century notion of the avant-garde, and Modernism is based, of course, on the myth of a romantic advance guard setting out before the rest of society to conquer new territory, new states of consciousness and social order. The metaphor of the avant-garde as a political and artistic military was formulated in the 1820s and although there were very few artists who were politically active, like Gustave Courbet, and even fewer that were agitating politically, like Marinetti, the myth of social activism sustained an elevated role for what was becoming a patronless class. Artists, like architects, were often underemployed and at the mercy of a heartless, or at least uninterested, economic system. Where before they had a defined social relationship to a patron – the State, Church or an individual – now they related to a marketplace that was competitive and agnostic.

One can thus see Modernism as the first great ideological response to this social crisis and the breakdown of a shared religion. Faced with a post-Christian society, the intellectuals and the creative elite formulated a new role for themselves, inevitably a priestly one. In

22 The two basic strands of Modernism are discussed by many critics. See for instance Renato Poggioli, *The Theory of the Avant-Garde*, Harvard University Press, Cambridge, Mass 1968. The discussion of Bradbury and McFarlane is particularly relevant; see their 'The Name and Nature of Modernism', in *Modernism 1890-1930* edited by Malcolm Bradbury and James McFarlane, Penguin Books, Harmondsworth 1976, pp. 40-1 and 46; Frank Kermode, 'Modernisms', in *Modern Essays*, London 1971. For architecture the best discussion is Robert Stern, 'The Doubles of Post-Modern', *The Harvard Architectural Review*, Vol. 1, Spring 1980 although, as my text makes clear, I would use the term Late-Modern for his 'Schismatic Post-Modern'.

23 Ihab Hassan, 'Joyce, Beckett, and the postmodern imagination', *Tri Quarterly*, XXXIV, Fall 1975, p. 200.

their most exalted role, they would heal society's rifts; in 'purifying the language of the tribe', they could purify its sensibility and provide an aesthetic-moral base – if not a political one. From this post-Christian role developed two positions and a contradiction between them that has caused much confusion. To deal with this confusion I shall resort, as others such as Frank Kermode and Robert Stern have done, to two technical terms because the word 'modern' hides at least two different meanings.[22]

There is the healing role of the artist, that of overcoming the 'split between thinking and feeling' which T.S. Eliot and Siegfried Giedion located in the nineteenth century, and this leads to what has been called 'Heroic Modernism'. Then there is the subversive and romantic role of the artist to conquer new territory, 'to make it new', to make art different, difficult, self-referential and critical: what I would call 'Agonistic Modernism'. These two meanings relate to what Stern labels 'traditional versus schismatic Modernism', humanism versus agonism, continuity versus 'the shock of the new', optimism versus nihilism, and so on. For Stern and other writers such as Ihab Hassan, the second of the traditions – schismatic or resistant Modernism – has itself mutated into schismatic Post-Modernism. Thus Hassan writes: 'Post-Modernism, on the other hand, is essentially subversive in form and anarchic in its cultural spirit. It dramatizes its lack of faith in art even as it produces new works of art intended to hasten both cultural and artistic dissolution.'[23]

As examples Hassan mentions the literature of Genet and Beckett – what George Steiner calls the 'literature of silence' – the self-abolishing art of Tinguely and Robert Morris, the mechanistic and repetitive art of Warhol, the non-structural music of John Cage and the technical architecture of Buckminster Fuller.[24] All of this takes Early Modernism and its notion of radical discontinuity to an extreme leading to the hermeticism of the 1960s and 1970s. Because this later tradition was obviously different from the Heroic Modernism of the 1920s quite a few critics loosely applied the prefix 'post'. For instance the popular critics Paul Goldberger and Douglas Davis used it in the *New York Times* and *Newsweek* to discuss the ultra-Modern work of Hardy, Holzman and Pfeiffer, Cesar Pelli and Kevin Roche, all of which exaggerates the high-tech work of Mies and Le Corbusier.[25] The art critic Edward Lucie-Smith, like others, even applied it to Piano and Rogers' Pompidou Centre.[26] In short, Post-Modern meant *everything* that was different from High-Modernism, and usually this

[22]

[23]

24 Ihab Hassan, *Paracriticisms: Seven Speculations of the Times*, University of Illinois Press, Urbana 1975, pp. 55-6.

25 For references see *The Language of Post-Modern Architecture*, fourth edition, *op. cit.*, p. 8.

26 The work of Archigram and Richard Rogers was often termed Post-Modern in the late 1970s before critics began to understand the term and its distinction from high-tech. Edward Lucie-Smith followed this usage in his book on Modernism published around this time.

meant skyscrapers with funny shapes, brash colours and exposed technology. That such architects were against the pluralism, ornament and convention of Post-Modernism was missed by these critics. They just adopted a current phrase for discontinuity and lumped every departure under it.

The same permissive categorisation was practised in artistic theory and criticism and so when conferences were held on the subject artists were confused as to whether they were supporting the Post-Modern, or against it.[27] In fact a whole book, *The Anti-Aesthetic: Essays on Postmodern Culture*, was dedicated to this confusion.[28] Here the editor Hal Foster uses it to mean a cultural and political resistance to the status quo. For one of the contributors, Craig Owens, it is the critical use of post-industrial techniques (computers and photography) in art and the 'loss of master narratives' (he follows J.F. Lyotard in this). Frederic Jameson uses it as an umbrella term to cover all reactions to High-Modernism (again John Cage and William Burroughs), the levelling of distinctions between high- and mass-culture and two of its 'significant features' – pastiche and schizophrenia. Jean Baudrillard refers to it as epitomising our era and its 'death of the subject' caused basically by television and the information revolution. ('We live in the ecstasy of communication. And this ecstasy is obscene'.[29]) Most of the remaining authors use it in different ways, some of which have a relation to resisting or 'deconstructing' the common assumptions of our culture. In short, it means almost everything and thus nearly nothing.

Before I discuss this 'Nothing Post-Modernism' where very little is at stake, I'd like to mention one of its causes: the view that the word can be appropriated to mean any rupture with High-Modernism. Rosalind Krauss's essay 'Sculpture in the Expanded Field' printed in this and another anthology on Post-Modern art shows this appropriation.[30] Her elegant and witty essay seeks to define all departures from sculpture that appear to break down the category of Modernist sculpture – let us say Brancusi's *Endless Column* – and expand them to include such things as Christo's *Running Fence* and wrapped buildings, Robert Smithson's use of earth-covered mirrors in the Yucatan, a wooden maze by Alice Aycock constructed in 1972, and various earthworks and 'marked sites' such as a sunken, framed hole in the ground executed by Mary Miss in 1978.

Krauss uses a structuralist diagram to draw this expanded field of

27 'Post-Modernism', a symposium at the Institute for Architecture and Urban Studies, 1981, attended by Christian Hubert, Sherrie Levine, Craig Owens, David Salle and Julian Schnabel, later published in *Reallife*, 30 March 1981.

28 *The Anti-Aesthetic: Essays on Postmodern Culture*, edited by Hal Foster, Bay Press, Port Townsend, Washington 1983.

29 *ibid.*, p. 130.

30 *ibid.*, pp. 31-42. See also the anthology *Theories of Contemporary Art*, edited by Richard Hertz, Prentice

sculpture – the objects that are *not* architecture, *not* landscape, indeed *not* sculpture, and her wit consists in making the diagram itself expand to include a lot of combined '*nots*'. The strategy is not dissimilar to the Modernist practice of defining things by what they are *not*, in order to maximise their differences and essentiality, but she presents their expansion as a 'rupture' with Modernism: '. . .One after another Robert Morris, Robert Smithson, Michael Heizer, [24] Richard Serra, Walter de Maria, Robert Irwin, Sol LeWitt, Bruce [25] Nauman (between 1968 and 1970) had entered a situation the logical conditions of which can no longer be described as modernist.'[31] In her diagrammatical, logical terms this is quite true, but then she goes on to make a false inference: 'In order to name this historical rupture and the structural transformation of the cultural field that characterizes it, one must have recourse to another term. The one already in use in other areas of criticism is postmodernism. There seems no reason not to use it.'

Oh yes there is *not*, to use the not-way of not-definition, for if one thing is not obscure it is that you can't define things usefully by what they are not. All the *things* in a room that are not men are not necessarily women: there is a near infinity of other classes of things. And those artists she mentions are not Post-Modernists, but really Late-Modernists. Why? Because like ultra- or Neo-Modernists they take Modernist disjunction and abstraction to an extreme. Essentially their practice goes against the thirty or so definers of Post-Modernism I have mentioned – all those connected with semantics, convention, historical memory, metaphor, symbolism and respect for existing cultures. Their work is much closer to Agonistic Modernism, except it is more extreme, exaggerated – in short, 'Late'.

Indeed this brings us to the essential definition of Late-Modernism: *in architecture it is pragmatic and technocratic in its social ideology and from about 1960 takes many of the stylistic ideas and values of Modernism to an extreme in order to resuscitate a dull (or clichéd) language.*[32] Late-Modern art is also singly coded in this way and like the Modernism of Clement Greenberg tends to be self-referential and involved with its art-specific language, even minimalist in this concentration as so many critics such as Umberto Eco have pointed out.[33]

Hall, New Jersey 1985, pp. 215-25. Post-Modernism is also discussed by various authors in a loose way in this anthology.

31 *op. cit.*, p. 39.

32 The essential definitions of Modern, Late- and Post-Modern were initially proposed by me in *AD News* 7/81, also published later in 'Post-Modern Architecture: The True Inheritor of Modernism', *Transactions 3*, RIBA, London 1983, pp. 37-40.

33 *op. cit.*, note 9, pp. 66-7.

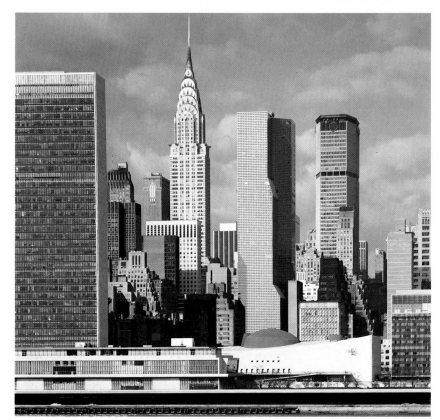

[22] Kevin Roche, John Dinkeloo and Associates, One UN Plaza, New York, 1974-6. Various Modernist skyscrapers are evident here: the flat 'dumb box' of the UN Secretariat, the lozenge-shaped Pan-Am Building and this faceted, skewed membrane of Kevin Roche. Termed Post-Modern by popular critics because of its distortions in scale, outline and mass, it is in fact typically Late-Modern. (Photo Kevin Roche, John Dinkeloo and Associates)

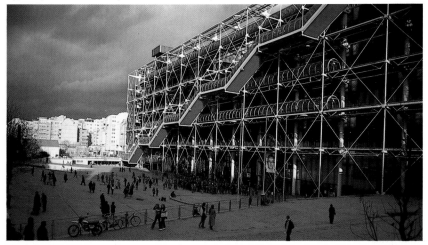

[23] Renzo Piano and Richard Rogers, Pompidou Centre, Paris 1971-7. The Modernist emphasis on structure, circulation, open space, industrial detailing and abstraction is taken to its Late-Modern extreme, although again often mis-termed Post-Modern. (Photo C. Jencks)

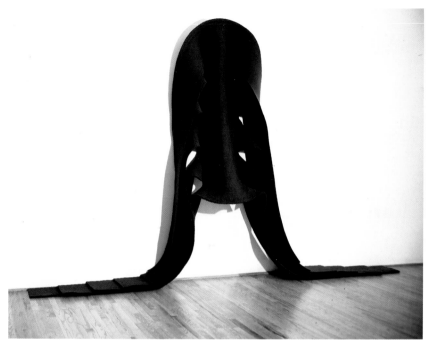

[24] Robert Morris, *Untitled*, 1970, brown felt, 72 x 216in, installed 96in high. Sculpture, as Rosalind Krauss defines it, becoming 'pure negativity: the combination of exclusions ... a kind of ontological absence'. Morris in the late 1960s reached some interestingly elegant dead ends such as here with the dark felt which, with its subtle logical twists, tells you it is 'not wall and not floor' but what's left over when you subtract these. (Courtesy of Saatchi Collection, London)

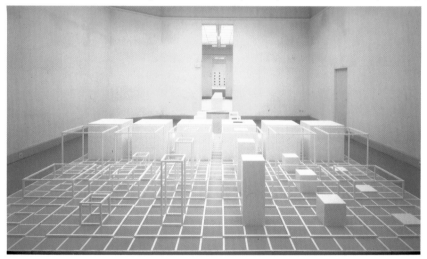

[25] Sol LeWitt, *Serial Project (A,B,C,D)*, 1966, white stove enamel on aluminium, 36⅝ x 226¾ x 226¾in. A series of mechanical operations carried out by others lend these geometrical works an architectural flavour. Ultimately this automatic sculpture, like the architectural machines of Hiromi Fujii and Peter Eisenman, is very beautiful in the way its white grids pop up everywhere like rabbits. Why the series isn't titled *A,B,C,D,E,F*, as mathematically would seem to be implied, is a proposition to contemplate. Conceptual and Minimalist art were both typical Late-Modern movements. (Courtesy of Saatchi Collection, London)

IV SCHISMATIC POST-MODERNISM IS LATE-MODERNISM

What I am suggesting here is not a minor shift in nomenclature, but a complete reshuffling of categories: that is to redefine as mostly 'Late' what Davis, Goldberger, Foster, Jameson, Lyotard, Baudrillard, Krauss, Hassan and so many others *often* define as 'Post'. It is mostly 'Late' because it is still committed to the tradition of the new and does not have a complex relation to the past, or pluralism, or the transformation of western culture – a concern with meaning, continuity and symbolism. I don't for a moment believe that these writers will agree with me, but I do believe that what is at stake is more than a pedantic distinction. It is a difference of values and philosophy. To call a Late-Modernist a Post-Modernist is tantamount to calling a Protestant a Catholic because they both practise a Christian religion. Or it is to criticise a donkey for being a bad sort of horse. Such category mistakes lead to misreadings, and this may be very fruitful and creative – the Russians read Don Quixote as a tragedy – but it is ultimately violent and barren.

[26] Try to read Norman Foster's recently completed Hongkong Shanghai Bank as a Post-Modern building and you will get as far as the 'non-door' where the two escalators are shifted at an angle to accommodate the Chinese principle of *Feng Shui*. Is it contextual or related to the buildings surrounding it and the vernaculars of Hong Kong and China? Only in the most oblique sense that it is 'high-tech' and one side has a thin, picturesque group of towers. Is it involved with the 'taste-cultures' of the inhabitants and users? Only in the subliminal sense that its 'skin and bones' suggest muscle power. According to the permissive definitions of 'Nothing Post-Modernism' it should be a member of this class, because it is a 'rupture' with
[27] Modernism and fully committed to the tradition of the new. Indeed most of its parts, adopted from aeroplane and ship technology, were purpose-built in different parts of the globe precisely to be new. It is the first radical 'multinational' building – parts were fabricated in Britain, Japan, Austria, Italy and America – resolved by all the technologies of the post-industrial society, including of course the computer and instant world communication, and therefore according to the definitions of J.F. Lyotard and others it should be a prime example of Post-Modernism. But it isn't, and if it were it would be a failure.

No, it has to be judged as the latest triumph of Late-Modernism and celebrated for what it intends to be, namely, the most powerful expression of structural trusses, lightweight technology, and huge open space stacked internally in the air. The cost of the building – and it is called the most expensive building in the world – directly reflects these intentions, for it turns out that the money went on the bridge-like structure and the superb use of finishing materials, surprising areas to take up so much of a budget. Thus, I don't mean

only to criticise the building for its Post-Modern shortcomings, but to support it for its Late-Modern virtues. These are, as usual, the imaginative and consistent use of the technical language of architecture. The morality of Late-Modernism consists in this integrity of invention and usage; like Clement Greenberg's defence of Modernist morality the work has to be judged as a hermetic, internally related world where the meanings are self-referential. Literally, does the high-tech fit together and work, visually, poetically and functionally? The answers to all these questions appear to be positive, although it is too soon to be sure.

The concept of Post-Modernism is often confused with Late-Modernism because they both spring from a post-industrial society. Of course there is a connection between these two 'posts', but not the simple and direct one that the philosopher Jean-François Lyotard implies. He opens his book *The Postmodern Condition: A Report on Knowledge* with the elision of the two terms: 'The object of this study is the condition of knowledge in the most highly developed societies. I have decided to use the word postmodern to describe that condition . . . I define *postmodern* as incredulity toward metanarratives . . . Our working hypothesis is that the status of knowledge is altered as societies enter what is known as the post industrial age and cultures enter what is known as the postmodern age.'[34]

Lyotard's study is mostly concerned with knowledge in our scientific age, in particular the way it is legitimised through the 'grand narratives' such as the liberation of humanity, progress, the emancipation of the proletariat, and increased power. These 'master narratives', he contends, have gone the way of previous ones such as religion, the nation-state and the belief in the destiny of the west; they've become non-credible and incredible. Indeed all beliefs, or master narratives, become impossible in a scientific age, especially the role and ultimate legitimacy of science itself. Hence the nihilism, anarchism and pluralism of 'language games' which fight each other, hence his belief that Post-Modern culture entails a 'sensitivity to differences' and a 'war on totality.'[35] Post-Modern is then defined as 'a period of slackening', a period in which everything is 'delegitimised'. Given this nihilism and the sociological jargon, one can understand why our Sunday reporter at *Le Monde* was so upset by the spectre about to descend, like a fog of waffle, onto the breakfast table. Lyotard has almost defined Post-Modernism as this 'slackening' relativity. But in another section he amazingly defines the 'postmodern' as pre-Modern: 'What space does Cézanne challenge? The Impressionists. What object do Picasso and Braque attack? Cézanne's . . . A work can become modern only if it is first postmod-

34 Jean-François Lyotard, *The Postmodern Condition: A Report on Knowledge*, Manchester University Press, 1984, pp. XXIII, XXIV and 3. The book was first published in French in 1979.

35 *ibid.*, pp. XXV and 82.

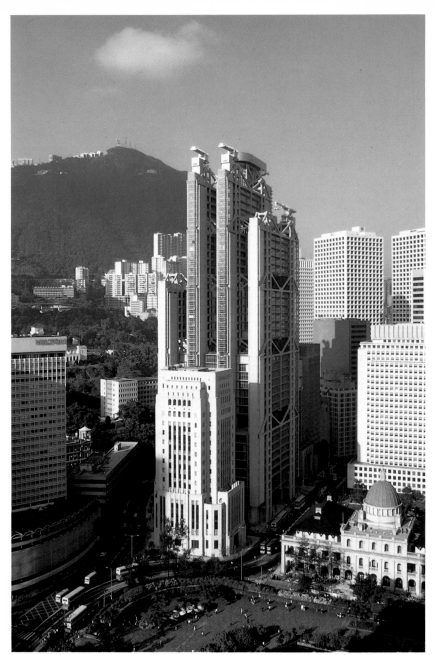

[26] Norman Foster and Foster Associates, Hongkong Shanghai Bank, Hong Kong, 1982-6. By adhering to local convention and breaking up the volume into slim towers, Foster has ironically fit into a Hong Kong that no longer surrounds this building. Judged as a Post-Modern work, the architecture fails to relate to either the tastes and conventions of the Chinese or the functions and styles of the bankers (although of course the elegant, steely-grey muscle is a calculated metaphor). But judged as the handmade Rolls Royce of Late-Modernism the building is indeed the triumph that the architectural profession has waited so long for: it is totally 'built' all the way through with every joint, balustrade and desk turned into a work of art – the apotheosis of Arts and Crafts philosophy. (Photo Ian Lambot)

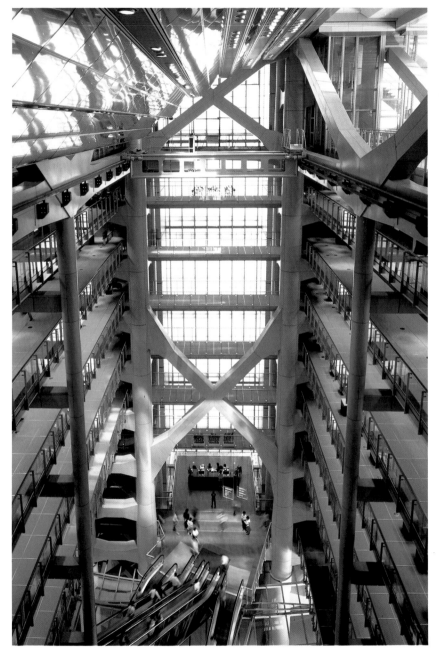

[27] Banking Hall. The 'Cathedral of Commerce', the metaphor of the 1920s skyscaper, is revived in this giant nave that pushes up nine storeys and then off to the right to catch some reflected light. Note the way trusses and columns break through the window walls expressing their Arts and Crafts 'honesty' (upper right and bottom); an interesting symbol of Modernist candour. On many levels this building is rigorously straightforward and thus quite awkward; truth is not always beauty. Whether or not it works well in a functional sense is a question for a future study. Surely it is well adapted for technological change and, in a sense, the culmination of sixty years of Modernist ideology. (Photo Ian Lambot)

ern. Postmodernism thus understood is not modernism at its end but in the nascent state, and this state is constant.'[36]

This crazy idea at least has the virtue of being original and it has led to Lyotard's belief in continual experiment, the agonism of the perpetual avant-garde and continual revolution. This also led to his exhibition of experiments with the media at the Pompidou Centre called *Les Immatériaux* which, from reports, appears to have been mis-labelled Post-Modernist. I'm not sure, since I haven't seen the exhibition, but it is clear that Lyotard continues in his writing to confuse Post-Modernism with the latest avant-gardism, that is Late-Modernism. It's embarrassing that Post-Modernism's first philosopher should be so fundamentally wrong.

However it is not surprising, because the 'mistake' has such a long pedigree, pre-dating Ihab Hassan's work, on which Lyotard rests for so much of his cultural evidence. Thus we are at a 'crisis' point – to use one of his concepts of legitimation – over whether to go on using the word Post-Modern to encompass two opposite meanings and diverging traditions. It is literally nonsense to continue with this linguistic confusion. Furthermore, I would argue that the meanings and definitions I have proposed – dichotomising Late- and Post-Modern – gain in power precisely to the extent that they are used together, because they elucidate opposite intentions, traditions of art and architecture which are fundamentally opposed to each other. Lyotard, because he is a philosopher and sociologist of knowledge and not a historian or critic of these cultural trends, is not finely tuned to their differences.

Having stated this case for a fundamental distinction between Post- and Late-Modernism, one should, however, add some refinements which modify an absolute difference. Both traditions start about 1960, both react to the wane of Modernism and some artists and [29-30] architects – for instance David Salle, Robert Longo, Mario Botta, Helmut Jahn, and Philip Johnson – either vacillate between or unite the two. This overlap, or existential mixing of categories, is what we would expect in any period after the Renaissance when, for instance, an artist such as Michelangelo could move from Early Renaissance to Mannerist and Baroque solutions of sculptural and architectural problems. So there are indeed many artists whom Hal Foster *et. al.* include in their corpus as 'postmodernists of resistance' that should also be included as Post-Modernists: Robert Rauschenberg, Laurie Anderson, some feminist art which uses conventional subject matter in an ironic way, Hans Haacke and others who might be termed 'Agonistic' or combative. But they should be so classified only in so far as their intention was to communicate with society and its professional elites through the use of double coding, and even if such artists are termed Post-Modern, it wouldn't guarantee their value

36 *ibid.*, p. 79.

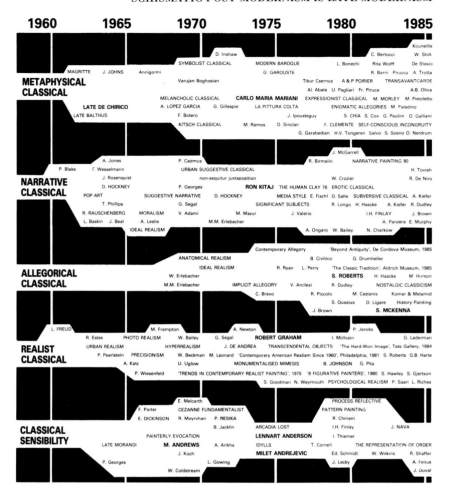

[28] Post-Modern Classical Art, 1960-80, the five main traditions. Again, as with architecture, there is a common approach which shows differences of focus. Some artists also tend to work concurrently within several traditions.

which must depend, as always, on the imaginative transformation of a shared symbolic system. The role of the critic must first be to define the field – that is the very real traditions which are evolving – and then make distinctions of quality and value, a process I have started with an evolutionary tree showing the five main Post-Modern Classical strands of art: the Metaphysical, Narrative, Allegorical and [28] Realist Classicists and those who share a classical sensibility. We can see in this return to the larger western tradition a slow movement of our culture, now worldwide, back to a 'centre which could not hold' (to misquote Yeats). The return has various causes, but among the most important is the idea that the value of any work must depend partly on tradition, both for its placement and quality. The tradition of the new made such a fetish of discontinuity that now a radical work of quality is likely to have a shock of the old.

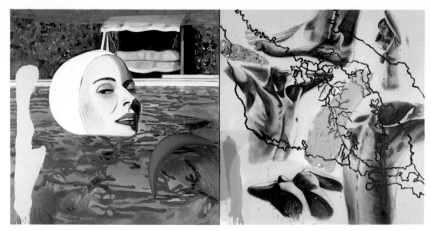

[29] David Salle, *The Cruelty of the Father*, 1983, acrylic and chair on canvas, 98 x 197in. Images from the mass-media and 'How to Draw' manuals blend with abstraction and a map outline within this diptych. Salle often juxtaposes Modernist and Classicist genres while letting the viewer supply the unifying interpretation. (Courtesy of Mary Boone Gallery, New York)

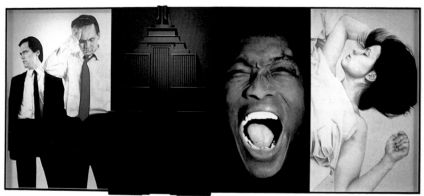

[30] Robert Longo, *Master Jazz*, 1982-3, mixed media, 96 x 225 x 12in. Executives fighting and frowning in a supercool environment are set against stereotypes of suffering and pleasure which, like those of Salle, are lifted from the media and presented with detached professionalism. Tough, descriptive realism relates to Early Modernism while the implied allegory tends towards the Post-Modern. (Courtesy of Metro Pictures, New York)

[31] Venice Biennale, *Strada Novissima*, 1980, [visible facades are by Leon Krier and J.P. Kleihues]. The *Strada* illustrates the 'return to architecture', to polychromy, ornament and above all to the notion of the street as an urban type. (Photo C. Jencks)

[32] Arata Isozaki, Tsukuba Civic Centre, Japan, 1980-3. Ledoux and Michelangelo, among others, are absorbed in Free-Style Classicism and rendered in High-Tech. The Japanese have always appropriated foreign influences and synthesised them for their own ends and styles. (Photo Satoru Mishima)

[33] O.M. Ungers, German Architectural Museum, Frankfurt, 1982-4. A white, gridded abstraction, reminiscent of Sol LeWitt and Peter Eisenman, has thematic elements − a house within a house − which, along with the collection of drawings, plans and models built up by Heinrich Klotz, establish it as *the* Museum of Post-Modern architecture. (Photo C. Jencks)

V THE COUNTER-REFORMATION IN ARCHITECTURE

The Heroic period of Modernism during the 1920s was not just confined to architecture but extended across the avant-garde in many arts. For a short time T.S. Eliot and Ezra Pound in literature, Stravinsky in music, Eisenstein in film, Brancusi in sculpture and Leger and Picasso in painting shared an implicit reformist role of shaping a new sensibility. The avant-garde and the intellectual elite defined a common role, that of being the leaders of a new mass-culture. This ideal of a new leadership resulted partly from the breakup caused as much by the First World War and the Russian Revolution as the industrial revolution. But its deeper roots went back to the nineteenth century and to the radical effects science, Darwinism and secularisation had on Christian culture. The post-Christian ideology, first proclaimed by Nietzsche as the philosophy of superman, was aimed directly at a creative elite and it is not surprising that the young Le Corbusier and Walter Gropius were brought up, as were so many artists of the early 1900s, on Zarathus-tra's oracular pronouncements: 'He who must be a creator in good and evil – verily, he must first be a destroyer, and break values into pieces . . . And whatever will break our truths, let it break! Many a house hath yet to be built. [It's clear why this appealed to architects.] Dead are all Gods; now we will that superman live . . . I teach you superman. Man is something that shall be surpassed. What have ye done to surpass him? . . . '[37]

The avant-garde took on this Darwinian role to 'transvalue all values' and Le Corbusier, reading these passages, even adopted the biblical intonation of his mentor. If one reads art and architecture manifestoes of the 1920s, from Berlin to Moscow to Paris, they all sound like this scripture but sent by telegram. And their evangelical style is basically Nietzsche's. Le Corbusier: 'A great epoch has begun. There exists a new spirit. Industry, overwhelming us like a flood which rolls on towards its destined ends, has furnished us with new tools adapted to this new epoch, animated by a new spirit. Economic law inevitably governs our acts and our thoughts . . . We must create the mass-production spirit. The spirit of constructing mass-produc-tion houses. The spirit of living in mass-production houses . . .'[38]

The rhetoric of a spiritual rebirth as proclaimed in New Testa-ments of the Machine Aesthetic finally drove out the Beaux-Arts evil and was enshrined in the Weissenhof Settlement, Stuttgart, in 1927. The white, Protestant Reformist style was built there by the major

37 Friedrich Nietzsche, *Thus Spake Zarathustra*, 1883, pp. 108 and 162, quoted from Will Durant, *The Story of Philosophy*, Washington Square Press, New York 1981, p. 417.

38 Le Corbusier, *Towards a New Architecture*, The Architectural Press, London 1927, p. 12.

architects from Europe and the impressive thing was not so much the quality of the buildings as the fact that the leaders had all practised versions of the same doctrine, a dogma that excluded convention, traditional craftsmanship and almost every quality that western architecture had enshrined except constructional beauty and dynamic space. Traditional aesthetics and urbanism were put on the Calvinist Index.

Fifty-three years later in the old Arsenale in Venice all this transvaluation was itself transvalued. Paolo Portoghesi and other critics and architects, including myself, organised the new Biennale of [31] Architecture around the theme 'The Presence of the Past.' Back were ornament, symbolism and the other taboos. The *Strada Novissima*, based on a Renaissance stage-set, consisted of twenty facades designed by leading Post-Modern architects. Most of them were in a Free-Style Classicism, a style which used the full repertoire of mouldings, keystones and columnar orders, but usually in an ironic fashion again indicating their place in history after Modernism, acknowledging that the return to tradition had to be based on current social and technical realities. Since then the most challenging Post-Modern Classicism has grown in strength to be practised around the world – even by the Indians and Japanese – using materials such as prefabricated concrete and aluminium. [32]

This Counter-Reformation has had its new saints and zealous bishops who have not failed to establish a renewed orthodoxy. Aldo Rossi, the new Italian pope of architecture, has issued decrees on Neo-Rationalism and the importance of memory for rebuilding the city (destroyed by Modernism). The idea of autonomous architecture – an architecture responding to its own typological laws of streets, squares and city blocks – has returned. The monument, which Modernists had declared forbidden goods, has been quickly reinstated in encyclical after encyclical. The most militant apostle, a veritable Ignatius Loyola, Leon Krier, has established his own following called Rational Architects, equivalent to the Society of Jesus. And these New Jesuits from Spain, Italy, Belgium and France have even insisted on building with ancient techniques of craftsmanship and stone. An indication of how powerful St Ignatius Krier has become, even without building a single structure, is that he was given a grand exhibition of his drawings in the High Church of Modernism, the Museum of Modern Art, in the summer of 1985.

The new doctrines spread very quickly with exhibitions in Helsinki, Chicago and Tokyo. A northern Vatican was established in Frankfurt where Heinrich Klotz made a thorough collection of Post-Modern [33] documents – drawings and models – in a building which could be called the first museum of Post-Modern architecture (especially designed by Matthias Ungers). If the 1927 Weissenhof exhibition represented the triumph of Protestantism, then the 1980 Venice Biennale and its subsequent re-erections in Paris and San Francisco

represent the triumph of the Counter-Reformation, its many Councils of Trent.

This metaphor, or mythology, of recent architecture is getting rather heavy but before I drop it a last parallel should be mentioned. The real Counter-Reformation resulted in the Baroque style (then called the Jesuit Style) and the building of many splendid churches replete with exuberant polychromy and narrative sculpture. All of this was a sign of a new spirituality and the new authority of the Church. While the stylistic parallel of the Counter-Reformation with Post-Modernism can be made – and there is even a new Baroque – there is no new religion and faith to give it substance. In place of this are several substitutes which form the agenda of Post-Modernism. The atheist art critic Peter Fuller, in his book *Images of God: The Consolation of Lost Illusions*, 1985, calls for the equivalent of a new spirituality based on an 'imaginative, yet secular, response to nature herself'.[39] His Post-Modernism, like my own, seeks 'a shared symbolic order of the kind that a religion provides', but without the religion. How this is to be achieved, he doesn't spell out any more than I do in four books on the subject.[40] But the examples from the past are objective standards against which we can measure Post-Modernism; artistic traditions may be more widely defined than scientific ones but distinctions of value can still be defined objectively.[41] Right-wing critics such as Roger Scruton, left-wing critics such as Fuller, and liberals such as Ernst Gombrich, agree on this and on condemning the relativism that Lyotard's position entails.[42] In both art and architecture the tradition of Post-Modernism is beginning to mature and we can see limited progress and development akin to that of the Renaissance.

39 Peter Fuller, *Images of God: The Consolation of Lost Illusions*, Chatto and Windus, London 1985, p. XIII.

40 The notion that Post-Modernists must attempt to develop a 'shared symbolic order' is a fundamental idea put forward in the books cited in note 10, as well as my *Post-Modern Classicism, Architectural Design* 5/6, 1980, and *Towards a Symbolic Architecture*, Academy Editions, London/Rizzoli, New York 1985.

41 This idea has been reiterated by E.H. Gombrich, among others; see his 'The Tradition of General Knowledge' and 'Art History and the Social Sciences' papers published in *Ideals and Idols*, Phaidon, London 1979, especially pp. 21-3 and 143-66.

42 *ibid.*, see also Peter Fuller's review 'Roger Scruton and Right Thinking', *op. cit.*, pp. 36-42.

Published in Great Britain in 1986 by Academy Editions, 7/8 Holland Street, London W8

Copyright © 1986 Charles Jencks & Maggie Keswick. *All rights reserved.* No parts of this publication may be reproduced in any manner whatsoever without permission in writing from the copyright holders

ISBN 0-85670-880-1

Published in the United States of America in 1986 by St. Martin's Press, 175 Fifth Avenue, New York, NY 10010

Library of Congress Catalog Card Number 86-042838 ISBN 0-312-86603-8

Printed and bound in Great Britain by E.G. Bond Ltd., London